POLITICAL CARTOONS AND CARICATURES

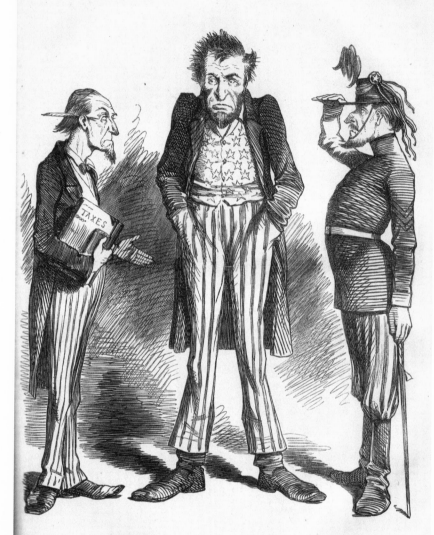

LINCOLN'S TWO DIFFICULTIES.

Lin. "WHAT? NO MONEY! NO MEN!"

Lincoln's Two Difficulties

Political Cartoons and Caricatures

from the collection of Michael Alexander Kahn

THE GROLIER CLUB
New York · 2007

Catalogue of an exhibition held at the Grolier Club

March 21–May 25, 2007

Curated by Michael Alexander Kahn and Jenny E. Robb

Design and typography by Jerry Kelly

ISBN 0-910672-72-5

TABLE OF CONTENTS

INTRODUCTION

For over two hundred and fifty years, political cartoons and caricatures have provided two important services to the populations of virtually every free country in the world. First, they have been a vehicle for exposing the hypocrisy, foibles and preposterousness of otherwise powerful and rich members of society, including royalty, political and military leaders and captains of industry. Second, they have popularized the most important political and social issues of the time in a manner in which injustices, misguided policies, and ridiculous government actions were instantly perceivable to wide audiences. The eighty items in the exhibit span two hundred and seventy-three years, five continents, eight languages, and a half dozen different forms of government but they all manifest these essential characteristics of political caricature.

The best political cartoons are almost invariably about current events and living people. Yet, because they so accurately summarize the issues and personalities of their times, they become historical artifacts which give the collector and student an incisive and accurate picture of the times. They are also art, and, regardless of their artistic merit, they are – as satire – entertainment.

Over forty years ago, I fell in love with political cartoons precisely because they were artistic and enjoyable and because they taught me so much history. My primary focus has been on American cartoons, particularly those found in

magazines such as *Puck, Judge, Harper's Weekly* and *Frank Leslie's Illustrated Magazine*. In addition, I have attempted to collect every available book about or containing compilations of political cartoons. The bulk of my collection, which contains over 5,000 items, consists of American political cartoon material.

America's political cartoon tradition, indeed, the entire Western world's political cartoon development, is rooted in Great Britain's brilliant cartoon past, dating from Hogarth in the 1730s to Gillray at the end of the 18th century. Early on, I collected English cartoon magazines and prints, and it was a small leap to begin collecting such items throughout Europe. During the last 10 years, my wife, Susan and I have traveled all over the world and have collected political cartoon books, magazines and prints in virtually every country we have visited from Uruguay to China, from New Zealand to Russia, from Turkey to Mexico and from India to Peru.

This exhibit is organized around our major collecting interests and is representative of political caricature at home and abroad. Thematically, the exhibit begins at the dawn of America and contains prints, books and sculptures dating from the American Revolution to the War of 1812, to the Civil War, to the Golden Age of political cartooning from 1865 to 1915, to the World Wars and culminating in a sculpture of our current President Bush. The exhibit also contains items from throughout the world, including the countries identified above, featuring, of course, items from England including Hogarth and Gillray pieces. Finally, the exhibit focuses on America's most important cartoonist, Thomas Nast, and on a

wide variety of history's most important and notorious figures, including Napoleon, Lincoln, Hitler, Ghandi and Churchill.

Political cartoons and caricatures are a rich cultural and historical treasure which are enjoyed by people all over the world. Hopefully, this exhibit will provide a glimpse of that treasure and a measure of enjoyment for everyone who views it.

Numerous people helped me prepare the exhibit and this catalog, and I am extremely grateful for their aid. I thank Lucy Shelton Caswell (Curator, The Ohio State University Cartoon Research Library), Richard West, Kerstin Konietzka-Knight, Laurie Pitman, Cornell Fleischer (Kanuni Suleyman Professor of Ottoman and Modern Turkish Studies at the University of Chicago) and Guoqing Li (Associate Professor and Chinese/Korean Studies Librarian at the Ohio State University) for their invaluable contributions to this project. Our colleagues at The Grolier Club, including Mark Tomasko, Jerry Kelly, Eric Holzenberg, Megan Smith, George Ong and Mary Young have been unfailingly helpful and patient. Greg Wilson and André Thélémaque helped prepare the items for presentation and my wife, Susan, has been instrumental in every aspect of this endeavor. Finally, every positive aspect of the exhibit is reflective of the wonderful work of Jenny Robb of the Ohio State University whose career in the field of cartoon art has no limits.

Michael Alexander Kahn

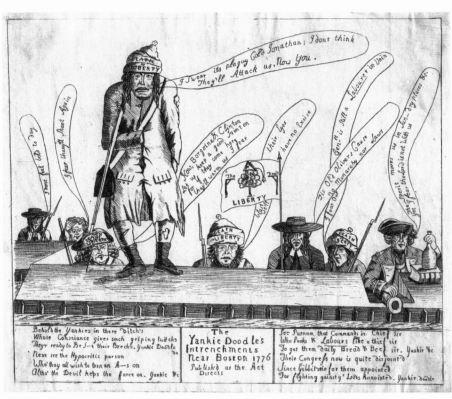

The Yankie Doodles Intrenchments Near Boston 1776

AMERICAN HISTORICAL CARTOONS: ANTEBELLUM

ARTIST UNKNOWN
The Yankie Doodles Intrenchments Near Boston 1776

Engraving, 1776

This print satirizing the Continental Army was originally thought to be created in Britain but is more likely a very early American print.[1] Satirical prints were extremely rare in the colonies at the time. This one is particularly exceptional because there are few pro-loyalist American cartoons.

The crude engraving shows a ragtag and cowardly rebel army besieging Boston. The figure on the right, Colonel Israel Putnam, is incorrectly identified as the commander of the colonial forces in the cartoon's verse. In fact, George Washington had been appointed commander-in-chief on June 15, 1775 and had taken over from temporary commander Artemis Ward on July 3. Ward and Putnam were made Major Generals. Putnam, a hero of the French and Indian wars, was probably better known and a more popular symbol of the rebellion than Washington at the time.[2]

Before the stars and stripes became the official flag in 1777, many other flags were used by the colonial forces. One depicted the Liberty Tree, an elm tree in Boston where a group of colonists calling themselves the Sons of Liberty met to protest the hated Stamp Act. The tree became a symbol of opposition to tyrannical British rule. It was cut down and used for firewood by loyalists in August of 1775 during the siege of Boston. The artist tops the Liberty Tree with a fool's cap and bell.

This print is also interesting for its religious symbolism. Two ministers, wearing the white tie and flat, wide-brimmed hat of Protestant ministers in New England at the time, are present among the militia. One compares the colonists' cause to the English Civil War which resulted in the execution of King Charles in 1649. In that conflict, the monarchy was replaced by a short-lived republic ruled by the Puritan Oliver Cromwell. Also, Putnam rests his rum bottle on a Bible as he voices his fear that "the Lord is not with us."

The Tea-Tax Tempest, or the Anglo-American Revolution

Engraving, c. 1778

This allegorical depiction of the American Revolution is an adaptation of a pro-colonial British print entitled *The Oracle* published by John Dixon in 1774. In Guttenberg's version, a winged Father Time projects a lantern slide onto the wall showing a teapot exploding over a sleeping British Lion while a cock representing France fans the flames of the fire under the teapot. France had officially entered the war on the side of the colonists in February of 1778. The cap and staff of liberty and a serpent erupt from the teapot. The use of a serpent as a symbol of the colonies can be traced back to the very first American political cartoon printed in a newspaper, *Join, or Die* by Benjamin Franklin. It depicted a snake cut up into pieces, with each section labeled for one of the colonies. Created in 1754, the cartoon encouraged unity during the French and Indian War and was widely reprinted. Many revolutionary flags depicted a rattlesnake accompanied by the phrase "Don't Tread on Me."

Behind the smoke, the colony's troops, led by a Native American woman reaching for the liberty cap, charge toward the panicked, retreating British forces. Viewing the slide with alarm, a Native American woman, an African woman and two Caucasian women representing Europe and Asia symbolize reactions from around the world.

ATTRIBUTED TO THOMAS ROWLANDSON[3]
The State Watchman

Published by I. Jones, Engraving, December 10, 1781

The sleeping figure on the couch has been identified as either King George III or Lord North, the Prime Minister of Great Britain during the American Revolution.[4] A distressed Britannia, the embodiment of Great Britain, questions his commitment to her protection while a short man attempts to wake him. In his book *Rowlandson the Caricaturist*, Joseph Grego identifies the small man as Sir Grey Cooper, North's Secretary of the Treasury, who sat on North's left in Parliament and frequently had to awaken the Prime Minister when he fell asleep during debates.[5] This criticism of the British government was published on the heels of its humiliation at the hands of the rebellious colonies, soon after the British surrender at Yorktown on October 19, 1781. Rowlandson, one of Britain's most famous caricaturists, is best remembered for his social commentary. This cartoon is a rare, early example of his political satire.

ARTIST UNKNOWN

Congressional Pugilists

Etching, 1798

This famous cartoon depicts an historic fight that occurred on the floor of Congress in 1798. It is often reprinted to demonstrate the lack of civility of early American politicians. The altercation took place between Republican Matthew Lyon of Vermont and Federalist Roger Griswold of Connecticut. Previously, the two men had exchanged insults that resulted in Lyon spitting in Griswold's face. A subsequent attempt to expel Lyon from the House failed, so Griswold chose to avenge his honor by attacking Lyon with a cane. Lyon grabbed the fireplace tongs to defend himself before the two could be separated.[6] News of the event spread through newspapers, correspondence, and broadsides, such as this crude depiction of the scuffle by an anonymous artist.

WILLIAM CHARLES

Johnny Bull and the Alexandrians

Published by William Charles, Etching and aquatint, 1814

and

WILLIAM CHARLES

John Bull and the Baltimoreans

Published by William Charles, Etching with roulette work, 1814

The War of 1812 found the British battling their former colonies. In this pair of prints, William Charles ridicules the cowardly capitulation of the Alexandrians and applauds the brave resistance of the Baltimoreans during the British offensive in August of 1814. The campaign led to the burning of Washington, D.C. and the capture of Alexandria but culminated in the U.S. victory at Baltimore. England is represented here by John Bull, literally a bull in seaman's clothes.

The defense of Baltimore and Ft. McHenry against British bombardment inspired Francis Scott Key to write the poem that became the *Star Spangled Banner*. The British fleet retreated for Jamaica on October 14, one week before these two prints were deposited for copyright.

ATTRIBUTED TO JAMES AKIN

The Pedlar and his Pack or the Desperate Effort, an Over Balance

Hand-colored etching and aquatint, 1828

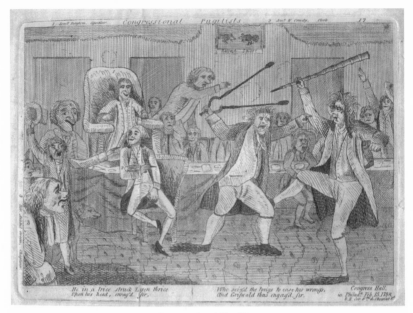

Congressional Pugilists

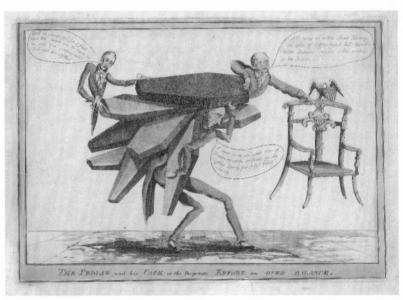

The Pedlar and his Pack or the Desperate Effort, an Over Balance

Democrat Andrew Jackson challenged incumbent John Quincy Adams in the election of 1828. This print demonstrates the rough and tumble political interchange including mudslinging and personal attacks that was typical throughout the election.

During the campaign, editor and Adams-loyalist John Binns published and distributed handbills illustrated with coffins blaming Jackson for executing soldiers and massacring Native Americans during his military career. In the cartoon, Binns is shown balancing numerous coffins on his back. Senator Henry Clay and Adams are perched atop the stack of coffins, with Adams attempting to hold on to the presidential chair. Binns threatens to drop the coffins if he doesn't receive "an extra dose of Treasury Pap," implying that he expected to receive government money for distributing the anti-Jackson propaganda.

The election of 1828 is considered the first truly democratic U.S. election because electors were chosen by popular vote, rather than by state legislatures, in all but two states. Jackson easily defeated Adams in both the popular and electoral votes. The opening up of the political process proceeded dramatically after this election.

ARTIST UNKNOWN
British Warfare in 1812, 1837-38
Published by H. R. Robinson, Hand-colored lithograph, c. 1838

Commercial lithography, introduced to the U.S. in the mid-1820s, provided a simpler, quicker and less expensive means of producing political broadsides than engraving or woodcut. At the same time, the audience for this type of commentary grew rapidly as more and more Americans became involved in the political process during the contentious Jacksonian era. As a result, the number of political cartoons increased dramatically in the 1830s and 1840s. By capitalizing on the new technology and audience, H. R. Robinson became the era's most prolific publisher of political satires.

Although slavery was abolished in all British colonies in 1833, former slaves were still indentured to their owners as apprentices until 1838, when this cartoon was published. It depicts the British seeking allies against the Americans by currying favor among the Native Americans during the War of 1812 and the African Americans in 1837 and 1838.

D. C. JOHNSTON

Metamorphosis: Martin Van Buren

Hand-colored etching, 1840

This fascinating souvenir of the presidential election of 1840 features incumbent candidate Martin Van Buren smiling while holding a glass labeled with his initials. The caption reads "A Beautiful Goblet of White House Champagne." When the tab at the bottom is pulled, his smile turns to a frown, the initials on the glass change to those of his opponent William Henry Harrison, and the caption reads "An Ugly Mug of Log Cabin Hard Cider." During the election, the Whigs depicted Van Buren as a champagne-sipping dandy while portraying Harrison as a humble frontiersman who lived in a log cabin and drank hard cider. In reality, Harrison was from a wealthy Virginia family. Harrison won the election, remembered for its raucous rallies and parades and considered to be the first modern presidential campaign.

D. C. JOHNSTON

Metamorphasis: A Locofoco Before and After the Late Election

Published by Redding & Co., Hand-colored etching, 1848

In this *Metamorphasis* card, the Locofoco's smile (complete with a missing tooth) turns to a frown when the tab is pulled from "Hurra for Cass!" to "What! Old Zack Elected." Locofocos were originally a radical faction of the Democratic Party, but by 1848, the term was used derogatively by the Whigs to indicate any Democratic supporter. Their candidate, Lewis Cass, lost the election to war-hero Zachary Taylor.

ARTIST UNKNOWN

The Constitution and Its Nurses

Published by Willis & Probst, Lithograph, c. 1844

A very rare broadside commenting on the presidential election of 1844, this cartoon includes four presidents: Martin Van Buren, Andrew Jackson, James Polk and John Tyler, along with perennial presidential hopefuls Henry Clay, Lewis Cass and Richard Johnson.

Tyler, the incumbent, had gained the office due to the death of William Henry Harrison, but soon after had broken with the Whig Party that had elected them. He used the issue of the annexation of Texas to rally support for his reelection bid, but later withdrew from the race on August 29.

Former President Van Buren sought to gain the Democratic nomination, but it went to dark horse candidate Polk, who had Jackson's support. Polk eventually beat the Whig nominee Clay. The cartoonist ridicules each candidate's desire to gain office and the policies each would impose on the Constitution, represented as a hapless baby.

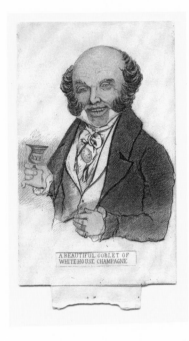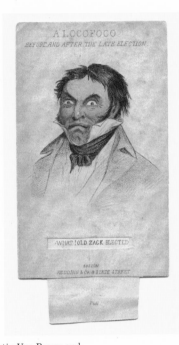

Metamorphosis: Martin Van Buren and
Metamorphasis: A Locofoco Before and After the Late Election

ATTRIBUTED TO LOUIS MAURER
The Great Exhibition of 1860

Published by Currier & Ives, Lithograph, 1860

Currier & Ives, the most prolific publishers of lithographed prints in the 19th century, included numerous political cartoons in their inventory. This cartoon ridicules the Republican Party and their abolitionist policy during the 1860 presidential election. Anti-slavery editor Horace Greeley is depicted as an organ grinder while a beardless Abraham Lincoln straddles the "Republican Platform" rail with his mouth padlocked shut. This is a reference to the fact that Lincoln did not give any speeches or interviews during the campaign. William Seward, however, toured the West speaking on behalf of Lincoln in the fall of 1860. While holding a black child, Seward decries attempts from some in the party to keep the slavery issue in the background.

Newspaper editors frequently appeared in political cartoons of this era, an indication of the important role they played in party politics and public life.[7] In addition to Greeley, the two figures on the right of the cartoon are also New York newspaper editors. James Watson Webb, editor of the *Courier and Enquirer*, is shown begging for money and "will even take three cents if we can't get more." To boost circulation of the *Courier and Enquirer*, Webb had recently lowered the price of the paper to three cents and hired boys to sell his paper on the street.[8] Henry J. Raymond, depicted as a newsboy, clings to Webb's arm. Raymond, a former assistant to Webb, had parted with him to start his own newspaper, the *New York Times*, in 1851.

ATTRIBUTED TO LOUIS MAURER
The Political Gymnasium

Published by Currier & Ives, Lithograph, c. 1860

This Currier & Ives cartoon demonstrates the fractured nature of the presidential election of 1860. The Republicans nominated Abraham Lincoln, who was not even on the ballot in nine Southern states. In the cartoon, a beardless Lincoln is shown atop a horizontal rail labeled " For

President." He is speaking to his supporter, editor Horace Greeley, who cannot quite mount his horizontal bar labeled "Nom. For Governor," a gibe at his unfulfilled aspirations for public office. Republican editor James Watson Webb is shown in the middle of a backward "summerset" or somersault, a reference to the fact that he had switched political party affiliations several times. William Seward, who had been the favorite for the Republican nomination before the convention chose Lincoln, stands to the right with bandaged feet and crutches, warning Lincoln "to be careful... that you don't tumble off as I did before I was fairly on."

The Democrats split into two factions, each with its own candidate. The Northern Democrats nominated Stephen A. Douglas while the Southern Democrats nominated John Breckinridge. In the cartoon they are shown as small boys boxing each other.

A third party, the Constitutional Union Party, nominated John C. Bell for president and Edward Everett for vice president. They are pictured to the left of the cartoon, with Everett holding Bell aloft on a bar bell, a comment on the fact that Everett was the more popular of the two in the North.

ARTIST UNKNOWN

The Political "Siamese" Twins: The Offspring of Chicago Miscegenation

Published by Currier & Ives, Lithograph, 1864

Conjoined twins, Chang and Eng, who were born in Siam (now Thailand) and were joined at the sternum, are the basis for this allusion to "Siamese" twins. Chang and Eng toured the U.S. and became celebrities in the 1830s. This device was subsequently used by cartoonists to ridicule political alliances. In this cartoon, the unlikely union is between pro-war Major General George B. McClellan (nick-named "Little Mac") and antiwar Democrat George Hunt Pendleton. They were nominated for president and vice president to run against Lincoln at the Democratic Convention in Chicago on August 29, 1864. On the left, a Union soldier exclaims "I would vote for you General, if you were not tied to a **Peace Copperhead**...." Democrats opposed to the Civil War were known as "Copperheads." Clement L. Vallandigham, leader of the Copperhead faction, and New York Governor Horatio Seymour, who opposed many of Lincoln's policies, are depicted on the right of the cartoon eagerly anticipating "peace at any price" if McClellan and Pendleton were to be elected.

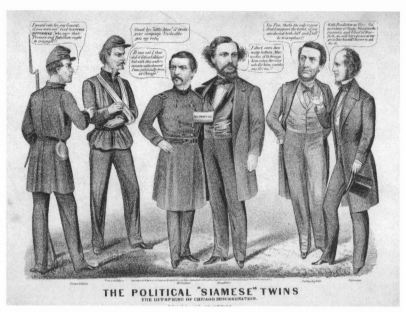

The Political "Siamese" Twins: The Offspring of Chicago Miscegenation

ATTRIBUTED TO JOHN L. MAGEE

Jeff. Davis Caught at Last. Hoop Skirts & Southern Chivalry

Published by J. L. Magee, Lithograph, c. 1865

This cartoon is one of many depicting the capture of Jefferson Davis in May 1865. The rumor that Davis had been trying to escape disguised as a woman captured the imagination of numerous cartoonists. In reality, Davis was wearing a cloak over his clothes as he attempted to leave his tent when two Union regiments, the Fourth Michigan and the First Wisconsin, surprised the group as they fled south. His wife had put a shawl over his shoulders at the last minute and instructed her maid to walk with Davis carrying a bucket, in hopes that the Union troops would think they were headed to the creek for water.[9] In many of the cartoons, such as this one, Davis is depicted carrying the bucket himself in full women's dress, including hoop skirts.

Ironically, there were cartoons of Lincoln allegedly slipping into the Capitol before his inauguration dressed as a woman. So we have a historical irony in that cartoonists lampooned Lincoln for slipping *into* government hiding in a woman's dress or in Scottish attire (depending upon legend), and Jefferson Davis allegedly slipping *out* in female dress.

JOHN CAMERON
The Radical Party on a Heavy Grade
Published by Currier & Ives, Lithograph, 1868

This 1868 campaign cartoon ridicules the Republicans, whose candidate Ulysses S. Grant labors unsuccessfully to pull the "Chicago Platform" wagon up-hill toward the White House. Sitting in the wagon are prominent members of the Republican Party, including *Tribune* editor Horace Greeley and General Benjamin Butler, who holds two spoons. Butler had earned the nickname "Spoons" for allegedly stealing silverware while serving as military governor of occupied New Orleans.[10] The head of Democratic nominee, Horatio Seymour, hovers over the White House, with rays of light emanating from it, indicating the cartoonist's view that Seymour would win the election.

The signature "On Stone by Cameron" refers to the method of printing. Artists drew their designs directly onto the lithographic stone, which was then treated and used to make prints. Lithographs such as this one were probably sold directly to political parties in bulk to be used as campaign propaganda.

JOHN CAMERON
Splitting the Party
Published by Currier & Ives, Lithograph, 1872

Once again the Republican Party comes under fire from John Cameron's lithography pencil. The cartoon depicts editor Horace Greeley as a wedge splitting the Republican Party stone. The Republicans had nominated incumbent Ulysses S. Grant in Philadelphia, but a disgruntled faction calling themselves the Liberal Republican Party split from the main party and nominated Greeley at their own separate convention in Cincinnati. The Democratic Party also nominated Greeley.

Prophetically, Grant and Senator Carl Schurz, who wields a mallet ready to drive the wedge further into the stone, both mention Greeley being killed. Grant states "My friend, you've got a soft thing on your wedge,

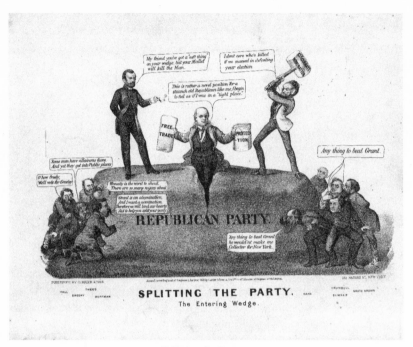

Splitting the Party

but your mallet will kill the man," while Schurz retorts "I don't care who's killed if we succeed in defeating your election." In fact, Greeley died shortly after the popular vote but before the Electoral College vote, which Grant easily won.

THOMAS NAST

Reform Without Bloodshed

Harper's Weekly, *Wood engraving, April 19, 1884*

After the Civil War, illustrated newspapers and comic weeklies featuring political cartoons gradually supplanted separate political prints in popularity. With the help of cartoonist Thomas Nast, *Harper's Weekly* built its reputation as a force for reform through its campaign against Boss Tweed and the corrupt Tammany Hall political machine in the late 1860s and early 1870s.

A decade later, Republican Theodore Roosevelt and Democratic Governor Grover Cleveland also took on the Tammany Hall political machine,

which had survived the downfall of the Tweed Ring. Nast's respect and admiration for the reform work being done by the two men, both future U.S. presidents, is clear. His depictions of them are more portrait than caricature. This is one of the earliest political cartoon images of Theodore Roosevelt, who was a young New York assemblyman at the time.

As the newspaper in the foreground indicates, violent riots had taken place earlier that year in Cincinnati, another city controlled by a corrupt party machine. In contrast, the cartoonist applauds honest Democrats and Republicans working together to achieve reform peacefully in New York.

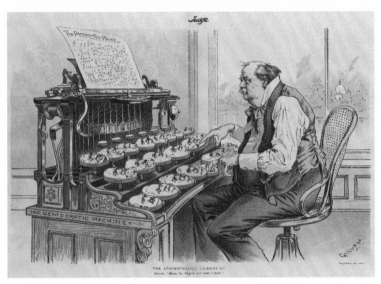

The Administration Typewriter

BERNARD GILLAM
The Administration Typewriter

Judge, *Chromolithograph, November 11, 1893*

This is a wonderful early depiction of a typewriter, which was still a relatively new convenience. Typewriters had only been sold commercially since the 1870s. This drawing was probably based on the Caligraph model, first introduced in 1880 and said to have remained in production until 1896.[11] Gillam's wonderful caricature of Democratic President Grover Cleveland captures the trouble that he had in getting the various factions of his own party to support his policies. A sweating and frustrated Cleve-

land sits at the typewriter while exclaiming "Blame the thing—I can't make it work!" The keys of the typewriter feature the faces of prominent Democratic leaders, including Tammany Boss Richard Croker, Secretary of the Treasury John Carlisle, Senator Daniel Voorhees, and Speaker of the House Charles Crisp.

CHARLES MARTIN

Mr. Clay Taking a New View of the Texas Question

February 6, 1847, in Yankee Doodle *(Vol. 1). New York: William H. Graham, 1847, p. 199.*

The inaugural issue of *Yankee Doodle*, one of the earliest American humor magazines, appeared in October 1846. It looked to the British comic weekly *Punch*, founded five years earlier, for inspiration. The most popular topic of its political cartoons was the Texas question. Senator Henry Clay's opposition to the annexation of Texas cost him the election of 1844 when he ran against expansionist James K. Polk. The electorate clearly favored annexing Texas, even though it would almost surely lead to a war with Mexico.

In a speech in 1846, Clay declared that he wished he could "slay a Mexican," implying that nothing less would revive his viability as a presidential candidate.

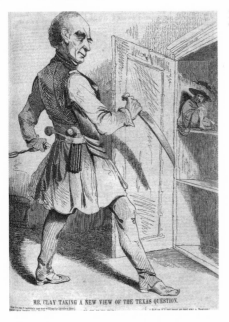

Mr. Clay Taking a New View of the Texas Question

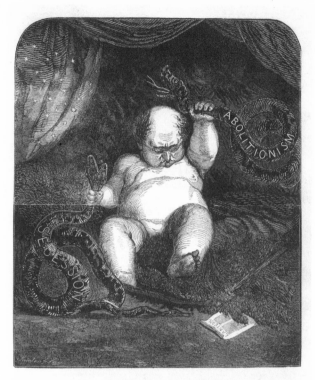

A PICTORIAL PARODY.

A Pictorial Parody

FRANK BELLEW

A Pictorial Parody

February, 1852, in The Lantern *(Vol. 1). New York: Stringer and Townsend, 1852, p. 57.*

Like *Yankee Doodle, The Lantern* was modeled on the hugely successful British comic weekly, *Punch*. It ran for seventy-eight issues, from January 1852 until June 1853.[12] The magazine was alternatively known as *Diogenes, Hys Lantern*. The name was taken from the Greek philosopher and Cynic, Diogenes, who was reported to have spent his life searching in the daylight with a lantern for an honest man.

The young Diogenes appears in this cartoon by Bellew strangling the serpents of both "abolitionism" and "secession," an allusion to the story in Greek mythology that Hercules strangled two serpents sent to kill him while he was still a baby.

Shaky

June 9, 1860, in Vanity Fair *(Vol. 1). New York: Louis H. Stephens, 1860.*

Vanity Fair (no relation to the current magazine of the same name) was perhaps the most successful of the early imitators of London's humor magazine, *Punch*. It appeared on the last day of December 1859 and was published until July 4, 1863. This early cartoon by founder and chief cartoonist Henry Louis Stephens depicts a beardless Lincoln early in the 1860 presidential campaign. He attempts to keep his balance while carrying a black child across a thin rail.

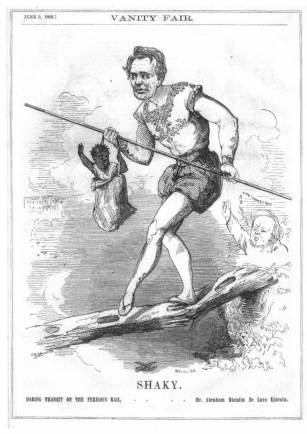

Shaky

HARPER'S WEEKLY.
A JOURNAL OF CIVILIZATION

Vol. XX.—No. 1035.] NEW YORK, SATURDAY, OCTOBER 28, 1876. [WITH A SUPPLEMENT. PRICE TEN CENTS.

Entered according to Act of Congress, in the Year 1876, by Harper & Brothers, in the Office of the Librarian of Congress, at Washington.

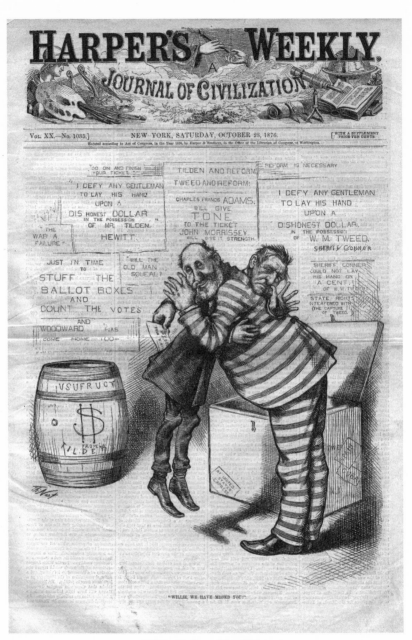

"WILLIE, WE HAVE MISSED YOU!"

Willie, We Have Missed You!

JOSEPH KEPPLER
Grantism

March 25, 1876, in Frank Leslie's Illustrated Newspaper *(Vol. 42, No. 1069). New York: Frank Leslie, 1876.*

Frank Leslie's Illustrated Newspaper, founded in 1855, competed with *Harper's Weekly* to be the leading news magazine of the day.[13] In contrast to *Harper*'s and its cartoonist Thomas Nast, *Leslie's Illustrated Newspaper* and Joseph Keppler were intensely critical of President Ulysses S. Grant. This cartoon satirizes the scandals and corruption that plagued Grant's administration, including the Whisky Ring, which resulted in the embezzlement of millions of dollars in liquor taxes, and the Indian trading post scandal, in which Grant's Secretary of War took bribes in return for selling trading posts.

THOMAS NAST
Willie, We Have Missed You!

October 28, 1876, in Harper's Weekly *(Vol. 20, No. 1035). New York: Harper and Brothers, 1876.*

Harper's Weekly, founded in 1857, grew to be the largest newsweekly by catering to a public hungry for news and images of the Civil War. Thomas Nast, its talented cartoonist, became the most celebrated and influential U.S. cartoonist of the century. His cartoon campaign against William "Boss" Tweed and the corrupt Tammany Hall ring that controlled New York City is often cited as an example of a cartoonist influencing the course of history, rather than simply reflecting it. Nast's cartoons are credited with helping bring about Tweed's downfall.

At the time this issue was published, Samuel J. Tilden was running as the Democratic candidate for president. Tweed had escaped from jail and fled to Spain, where authorities identified him from Nast's cartoons and arrested him in early September of 1876. Republican President Grant (who was not running for reelection) attempted to bring Tweed back to the U.S. before the November election in order to embarrass Tilden and the Democrats. He sent a Navy ship to transport the fugitive, but bad weather kept it from delivering Tweed to the U.S. until after the election.[14] Although Tilden had been instrumental in bringing down the corrupt Tweed ring, Nast suggests an association between the two Democrats and a lack of sincerity in Tilden's reform efforts.

JOSEPH KEPPLER

A Stir in the Roost. What! Another Chicken?

March 1877, in Puck *(Vol. 1, No. 1). New York: Puck Publishing Co., 1877-1878.*

Puck became the first widely popular and profitable humor weekly in the U.S. This is the cover of the first English issue (the magazine was originally published in German only), which depicts the birth of *Puck* witnessed by figures from the New York newspaper industry. The format of *Puck*, including lithographed, color cartoons on both covers and in the center spread, became the standard for almost all subsequent comic weeklies. Cartoonist Keppler was a founder and part owner of the Democratic magazine. The *Puck* mascot carries a lithographic crayon in the masthead and the cartoon.

J. A. WALES

The Two Political Dromios

October 29, 1881, in Judge *(Vol. 1, No. 1). New York: Judge Publishing Co., 1881.*

Judge was an imitator and successful competitor to *Puck*. It was started by a group of cartoonists led by James Albert Wales, who left *Puck* when his efforts to become part-owner were rebuffed. This cover cartoon from the first issue indicates that the intention of the magazine was to remain independent in its politics, although by 1886, it was reorganized as a Republican voice.[15] The cartoon, by Wales, depicts Republican Roscoe Conkling and Democrat John Kelly as Dromios in jester outfits standing in front of the two party's headquarters, each door displaying a sign reading "No Bosses Wanted." The two party bosses, who both supported the patronage system of appointing political supporters to government jobs, ask "What are we going to do about it?" Dromios were identical twin servants in Shakespeare's play *The Comedy of Errors*.

C. W. WELDON

Hancock Parrot to Uncle Sam.—"I've had a _____ of a time."

November 10, 1880, in Chic *(Vol. 1, No. 9). New York: Chic Publishing Co., 1880.*

The humor magazine *Chic* was a short-lived imitation of the popular *Puck*. It copied *Puck*'s size and format, including featuring lithographed political cartoons on the front cover. *Chic* was launched during the 1880

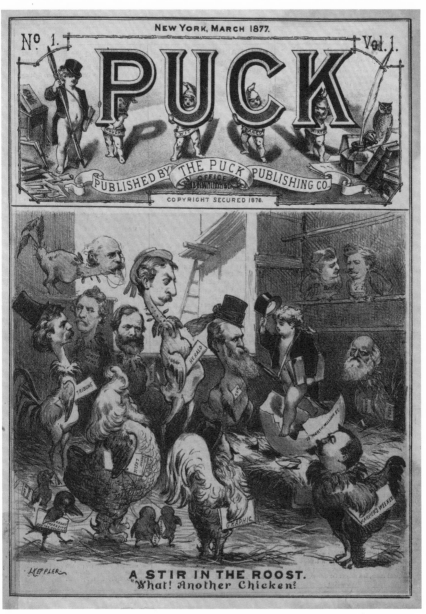

A Stir in the Roost. What! Another Chicken?

presidential campaign between Democrat Winfield S. Hancock and Republican James A. Garfield and only lasted one year. In this cartoon, Uncle Sam stands in the doorway of a room in shambles. Garfield, depicted as a monkey, has plucked the Hancock parrot clean of all but one feather. Each feather represents a northern state, with only the feather labeled "New Jersey" remaining on the otherwise bare bird. This cartoon appeared after the November 2nd popular vote resulted in Garfield winning all of the Northern states except New Jersey.

J. A. WALES
Tammany Accepts the Candidate

October 15, 1884, in Jingo *(Vol. 1, No. 6). New York and Boston: Art Newspaper Co., 1884.*

Jingo was another colorful weekly magazine that copied the format of *Puck*. It appeared just before the presidential election of 1884 with a vehement anti-Democratic message. In this cartoon, J.A. Wales ridicules the Democratic national convention which nominated Grover Cleveland. Thomas Grady of Tammany Hall in New York City criticized the reform-minded Cleveland in a speech but was unable to prevent him from winning the nomination. Cleveland subsequently won the election and *Jingo* folded soon after, lasting only eleven issues.[16]

HORACE TAYLOR
As Sure as Fate

November 1, 1890, in Light *(Vol. 3, No. 63). Chicago: Light Publishing Co., 1890.*

Light went through numerous changes during its short run lasting from 1889-1891. Originally founded in Columbus, Ohio as *Owl*, the magazine's owners moved it to Chicago and changed the format several times. By the time this issue was published, *Light* was copying the format of *Puck* and *Judge*. None of the changes made it a profitable venture, however, and it disappeared in June 1891.[17]

The cartoon by Horace Taylor predicts the defeat of Illinois congressman William E. Mason in the upcoming election. Mason had pushed through a bill intended to give the coal firm Walker, Whitehead and Co. a license to use a government pier in Chicago. Opponents of the bill maintained it was really a scheme to give the Illinois Central railroad company valuable docking privileges. Mason subsequently lost the election.

CHARLES DANA GIBSON
The Tourney

March 8, 1888, in Life *(Volume 11, No. 271). New York: Mitchell & Miller, 1888, p. 137.*

Life, founded in January 1883, was another humor magazine modeled after the British *Punch*. Its cartoons were printed in black and white in contrast to *Puck* and *Judge*'s chromolithographs. Like *Puck* and *Judge* (and unlike scores of earlier *Punch* imitators), *Life* enjoyed a long and successful run. It became one of the most popular and influential humor magazines of the era, thanks in part to its talented cartoonist, Charles Dana Gibson. He is remembered for his "Gibson Girl" cartoons which set the standard of style and fashion in the late 19th and early 20th centuries.

Gibson was not as well-known for his political cartoons. This example dates from early in the 1888 presidential campaign before a challenger to incumbent Grover Cleveland had been chosen. James Blaine, who had lost to Cleveland in 1884, was thought to have indicated interest in receiving the nomination again, but he later refused to be put forward. The Republican nomination went to Benjamin Harrison.

ROBERT MINOR, ## Tick-Tack Toe

BILLY IRELAND, ## He Got It

JAMES NORTH, ## Talking Through Lincoln's Hat

CHARLES BOWERS, ## Well, It Surely Was Hot

March 1912, in Cartoons *(Vol. 1, No. 3). Chicago: H.H. Windsor, 1912, p. 4-5.*

The monthly magazine *Cartoons* reprinted political cartoons from around the country and the globe along with interpretive articles on the issues and events of the day. Founded in 1912, it survived in this format until 1921. The cartoons were generally grouped according to themes and treated as serious journalistic contributions.[18] The theme of the four cartoons shown here in the first issue is Teddy Roosevelt, who was no longer president but clearly was still influential.

HENRY BARKHAUS
Behind the Scenes

August 2, 1884, in Kenneth M. Johnson. The Sting of the Wasp. San Francisco: The Book Club of San Francisco, 1967.

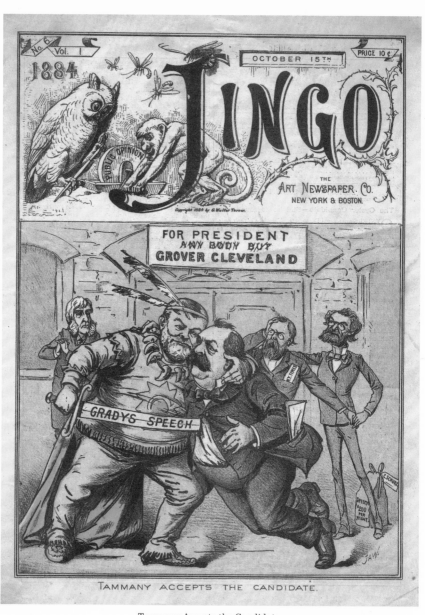

Tammany Accepts the Candidate

The *Wasp* was originally founded in 1876 by the Korbel Brothers, later famous for their California sparkling wine. It was published in San Francisco and had a West Coast circulation and influence, but also commented on national issues. Its two-page center spread featured stunning satirical chromolithographs. By 1884, when this cartoon was published, noted satirist and critic Ambrose Bierce was its able editor. The cartoon by Henry Barkhaus depicts railroad magnate Charles Crocker controlling puppet David McClure, the California delegate to the Republican National Convention in 1884. This book, which reproduced some of the *Wasp*'s cartoons, was limited to an edition of 450.

BERNHARD GILLAM
Phryne Before the Chicago Tribunal
Puck, *Chromolithograph, June 4, 1884*

This cartoon was published by *Puck* magazine during the heat of the extremely close Blaine-Cleveland presidential race of 1884. The portrayal of James Blaine as a tattooed man became a theme of numerous subsequent cartoons which Blaine blamed for his narrow defeat. Following the election, Blaine only reluctantly agreed not to sue *Puck* and Gillam for libel.

In the summer of 1969, D. B. Hardeman, a former aid to Speaker Sam Rayburn and one of the nation's leading authorities on Congress, introduced me to this cartoon and the world of political cartoons, nineteenth-century style. Hardeman discussed this cartoon as the most famous in the history of presidential elections because of its ability to permanently brand the candidate in the voters' minds.

CARICATURES WITH THE HAT THEME

JOSEPH KEPPLER
The Raven
Puck, *Chromolithograph, August 13, 1890*

and

JOSEPH KEPPLER
Where Is He?
Puck, *Chromolithograph, November 16, 1892*

These two cartoons were published in the Democratic *Puck*, the groundbreaking weekly humor magazine which featured beautifully illustrated double-page political cartoons in each issue. In this famous series, Keppler uses an overly large beaverskin hat to lampoon Republican presidential candidate Benjamin Harrison as not being able to live up to his grandfather, President William Henry Harrison. Benjamin Harrison was called "Little Ben" by the Democrats because of his short stature, so the Republicans had countered that he was big enough to wear his grandfather's hat.[19] Ironically, the elder Harrison died after only one month in office so had accomplished little. The younger Harrison won the 1888 election, but lost his bid for a second term in 1892. "Where Is He" was published shortly after the 1892 election. Uncle Sam is shown peering into the hat, which has presumably engulfed Harrison.

PAUL CONRAD
George W. Bush
Bronze, 2004

Paul Conrad served as the political cartoonist for the *Los Angeles Times* from 1964 until 1993. He won three Pulitzer Prizes during his tenure. Conrad sculpted a series of bronze caricatures of U.S. presidents. In this caricature of George W. Bush as a cowboy hat on a pair of cowboy boots, the hat theme is used to indicate a diminishment of the president, referring both to his father's hat and also to the concept of "all hat, no cowboy." Interestingly, the July 17, 2006 issue of *Time Magazine*, entitled "The End of Cowboy Diplomacy" pictured George Bush as just a big hat on cowboy boots exactly as Conrad had lampooned him.

CHINESE CULTURAL REVOLUTION PROPAGANDA POSTERS

[Black Figures Parade]

c. 1968

and

[Gang of Four]

c. 1976

These posters were purchased on the streets of Shanghai in 2005. They were mass produced and distributed by the Communist

[Gang of Four]

government during and after the Cultural Revolution. In China and other communist countries with little or no free speech, cartoons were used as instruments of government propaganda.

The first cartoon is an example of propaganda for the Cultural Revolution. It negatively depicts a parade of Communist Party members that the leaders of the Cultural Revolution wished to discredit including, ironically, Deng Xiaoping, who later rose to the top of China's political leadership. Mao Zedong, the Chairman of the Party, launched the Cultural Revolution in 1966.

The second cartoon ridicules the Gang of Four, a radical and powerful group of Communist Party leaders during the Cultural Revolution. The group included Mao's wife Jiang Qing and her three closest associates: Wang Hongwen, Zhang Chunqiao, and Yao Wenyuan. After Mao's death in 1976, a rival communist faction took power and the Gang of Four members were arrested and tried for treason. This poster was part of a media campaign by the government discrediting the Gang and blaming them for the excesses of the Cultural Revolution.

BRITAIN'S GREATEST CARTOONISTS: HOGARTH AND GILLRAY

WILLIAM HOGARTH
Untitled illustration

Engraving, in Samuel Butler. Hudibras. *London: Richard Wellington, 1733, p. 182.*

William Hogarth is considered the father of modern caricature and the founder of Great Britain's rich tradition of graphic satire. This edition of Butler's satirical poem *Hudibras*, originally written between 1663 and 1678, was Hogarth's first major commission.[20] The illustration depicts numerous common townspeople in a variety of action-filled poses reminiscent of the characters in Hogarth's famous works *A Rake's Progress* and *Marriage á la Mode.*

ARTIST UNKNOWN, AFTER WILLIAM HOGARTH
The Politician

Engraving and etching, Date unknown, originally published 1775

This charming and gentle caricature is based on one of Hogarth's sketches and was originally engraved by John Keyse Sherwin. It depicts a politician, possibly Hogarth's friend Ebenezer Forest, accidentally setting his hat on fire while reading a newspaper. It was first published by his widow Mrs. Jane Hogarth in 1775. Numerous editions were subsequently issued. This undated print is a reverse copy of the original.

ARTIST UNKNOWN, AFTER WILLIAM HOGARTH
Simon Lord Lovat

Etching, Date unknown, originally published August 14, 1746

Simon Fraser, Lord Lovat, led a life of intrigue and deception. He was involved in the Jacobite rebellion of 1745 in Scotland when Bonnie Prince Charlie attempted to regain the British throne for the Stuart line. He was subsequently arrested and sat for a portrait by Hogarth on the way to his trial in 1747, where he was found guilty and eventually executed. He was the last man to be beheaded in England. This undated print is a reverse copy of the original.

JAMES GILLRAY

Evidence to Character, ___being, a Portrait of a Traitor, by his Friends & by Himself

Published by John Wright, Etching, October 1, 1798, in Anti-Jacobin Review and Magzine *(Vol. 1). London: J. Whittle and C. Chapple, 1799, p. 285.*

James Gillray began his career attacking the Tories and King George III. However, by the late 1790s, he had become more conservative and accepted a pension from Tory Prime Minister Pitt. The *Anti-Jacobin Review and Magazine*, with close ties to the Tory government, ridiculed French Jacobinism and the Whig opposition.

This print depicts the trial of Arthur O'Connor, a member of the United Irishmen, a republican group seeking independence from Great Britain. The Irish rebels sought assistance from France, who attempted an unsuccessful invasion of Ireland in October of 1798. Whig politicians, including Charles James Fox, served as character witnesses at O'Connor's trial, which damaged their reputations when he confessed.

JAMES GILLRAY

An Old English-Gentleman Pester'd by Servants Wanting Places

Published by Hannah Humphrey, Hand-colored etching, May 16, 1809

King George III is shown surrounded by the leading politicians of the day seeking a place in the government. At the time, it was thought that the current administration led by the Duke of Portland would not continue for long. In fact, he resigned in October of 1809.

JOHN T. MCCUTCHEON, **All Would Be Well If the Men Were as Good as the Boys**

CAREY ORR, **Paper Hanger's Jitters**

JOSEPH PARRISH, **Let 'em Get a Load of This**

CAREY ORR, **Rommel's Painful Discovery**

> *July 5-7, 1942, in* War Cartoons by McCutcheon, Orr, Parrish, Somdal. *Chicago: The Tribune Co., 1942, pp. 128-129.*

> Cartoon reprint books on a single topic are particularly popular, especially ones that focus on specific personalities or major events such as wars or elections. This page features patriotic World War II cartoons from John T. McCutcheon, Carey Orr and Joseph Parrish. It is interesting to note that the *Chicago Tribune* had four political cartoonists at this time. Today, newspapers rarely have more than one cartoonist on staff, and many, such as the *Chicago Tribune*, have none. The *Tribune* has not employed a staff cartoonist since the death of Jeff MacNelly in 2000.

BILL MAULDIN

I'm jest a country doctor

> *May 13, 1944*
>
> and

Quit beefin' or I'll send ya back to th' infantry.

> *June 20, 1944, in Bill Mauldin.* Up Front. *New York: Henry Holt and Company, 1945, pp. 120-121. First edition.*

> Bill Mauldin was perhaps the greatest and most beloved World War II cartoonist. His scruffy characters Willie and Joe came to symbolize the average American G.I. This is a first edition of the best-seller that collected his wartime work. Mauldin won the Pulitzer Prize at the age of 23 in 1945 and again in 1959.

SGT. BILL MAULDIN

Star Spangled Banter

> *Washington, DC: Army Times Publishing Co., 1944.*

Willie and Joe first appeared in the *45th Division News* in 1940 and later moved to the Mediterranean edition of *Stars and Stripes*. This early reprint magazine indicates the popularity of the cartoons, even though some military leaders, including General George Patton, disapproved of Mauldin's portrayal of soldiers.

RAMIZ GÖKÇE
Bu Harbin Karikatür Albumü.
Turkey, 1944.

This Turkish album collects World War II political cartoons by Ramiz Gökçe. In his introduction, the cartoonist writes, "If, one day when the world has been restored to peace and prosperity, my drawings can make you look at today's situation that makes one weep with a smile of irony and understanding, what felicity for them!"[21] The cover features a smiling Franklin Delano Roosevelt and a cigar-smoking Winston Churchill, both flashing a victory sign, in a ship with other World War II leaders such as Joseph Stalin, Adolf Hitler, Benito Mussolini and Emperor Hirohito.

ARTIST UNKNOWN
The Question of Neutrality
Der Sturmer, *April 1940*
and

LESLIE GILBERT ILLINGWORTH
Two-Gun Winston
Daily Mail, *May 13, 1940, in Fred Urquhart. W. S. C.: A Cartoon Biography. London: Cassell & Co., Ltd, 1955.*

Many cartoon books are devoted solely to a single figure—usually politicians, such as this one featuring cartoons about Winston Churchill. This book has particular significance to me because it was the first cartoon biography I ever read when it turned up in my parent's home during the 1950s. Interestingly, both 1940 cartoons shown here, one from Germany's *Der Sturmer* and the other from the British *Daily Mail*, are critical of Churchill, although to differing degrees. The German cartoon portrays him as the vicious murderer of a helpless woman who represents "neutrality." Illingworth's cartoon depicts him as a cowboy wielding guns labeled "Premier" and 'Defence" in response to Churchill's announcement that he would hold the positions of both Prime Minister and Minister of Defence in his newly-formed government.

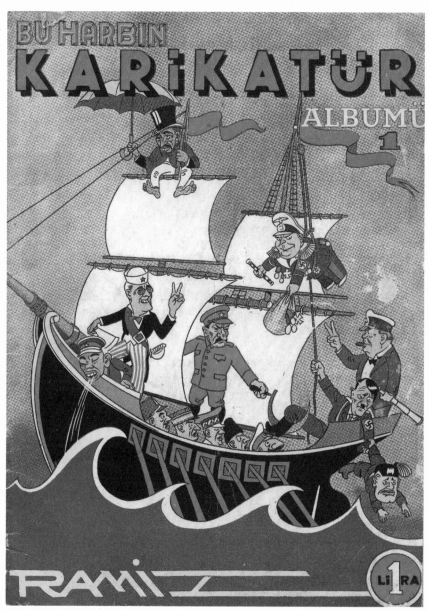

Bu Harbin Karikatür Albumü

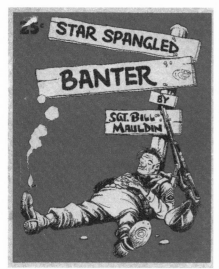

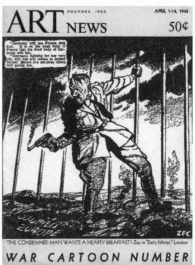

Star Spangled Banter

The Condemned Man Wants a Hearty Breakfast

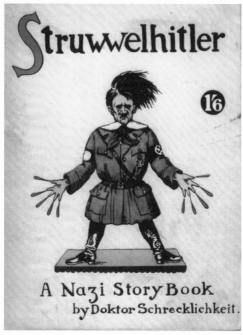

Struwwelhitler

PHILIP ZEC

The Condemned Man Wants a Hearty Breakfast

April 1-14, 1943, in ARTnews *(Vol 42, No. 4). New York: The Art Foundation, Inc., 1943.*

ARTnews is one of the oldest and most widely circulated art magazines in the world. This wartime issue features a reprint of a grim and powerful cartoon by the British political cartoonist, Philip Zec. It originally appeared in the *Daily Mirror* newspaper.

GEORGE BUTTERWORTH

Adolf and His Crazy Gang

Manchester: Allied Newspapers Ltd., c. 1943.

This compilation of cartoons by George Butterworth is one of many books satirizing Adolf Hitler. The pamphlet contains fifty cartoons from the *Daily Dispatch* ridiculing Hitler and his German high command.

ARTIST UNKNOWN

Untitled

Le Rempart, *December 11, 1933*

and

JERRY DOYLE

Improve! What Do You Mean, Adolf?

Philadelphia Record, *December 22, 1933, in* Ernst Hanfstaengl, Tat Gegen Tinte: Hitler in der Karicature der Welt [Fact vs. Ink: Hitler in the World's Cartoons]. *Berlin: Verlag Braune Bucher Berlin Carl Rentsch, c. 1933, p. 122-123.*

This fascinating collection of cartoons criticizing Hitler was commissioned by Hitler himself. The editor Ernst Hanfstaengl was a friend of Hitler's and his Foreign Press Secretary. The book was published for a German audience with the intent to discredit the views expressed in the cartoons. The book sold well, but it is impossible to know if it was successful as a piece of Nazi propaganda.

ROBERT AND PHILIP SPENCE

Struwwelhitler: A Nazi Story Book by Dokter Schrecklichkeit

London: Daily Sketch and Sunday Graphic Ltd, c.1940.

Yet another book lampooning Adolf Hitler, this is a parody of the book *Der Struwwelpeter*, created by German physician Heinrich Hoffman to amuse his son in 1844. It contained illustrated stories in verse about naughty children who get their due. Hitler is depicted on the cover as Struwwelpeter (Shockheaded Peter), a slovenly child who refuses to have his hair or nails cut.

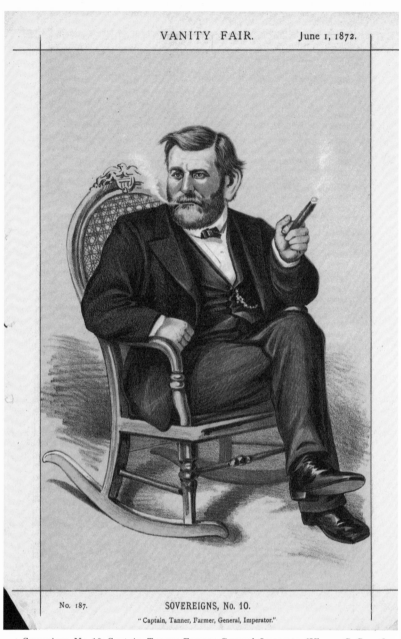

Sovereigns, No. 10: Captain, Tanner, Farmer, General, Imperator [Ulysses S. Grant]

PERSONAGES

THOMAS NAST
Sovereigns, No. 10: Captain, Tanner, Farmer, General, Imperator [Ulysses S. Grant]
Vanity Fair, *Chromolithograph, June 1, 1872*

The British magazine *Vanity Fair* is best remembered for its series of caricatures of famous personalities including politicians, entertainers, scholars, authors and royalty. The magazine was published from 1868 to 1928 (and has no relation to the American Conde Nast magazine of the same name.)

This extremely unusual and attractive portrait of President Ulysses S. Grant appeared at the end of his first term, shortly before he was nominated to run for reelection by the Republican Party in 1872. Nast's sympathetic caricature reflects the fact that he was a keen supporter and friend of Grant.[22]

PAUL CONRAD
Nixon Web
Originally published in The Los Angeles Times, *1973, Lithograph (#25 / 100)*

Conrad's cartoons during Watergate mercilessly ridiculed Nixon. In 1973, the year this cartoon was originally published in the *Los Angeles Times*, Conrad was included on Nixon's Enemies List.

Ghandi in Cartoons.
Bombay, India: Navjivan Trust, 1970.

This collection features cartoons about Mahatma Ghandi, who led India's movement for independence from Great Britain through the practice of non-violent resistance and civil disobedience. The British imperialists brought their tradition of political cartoons and caricatures with them to India in the nineteenth century. The magazine *Punch* was particularly influential and had numerous Indian imitators.[23]

Ghandi figurine

Mixed media

This sculpture of Ghandi was purchased in Peru.

WILLIAM S. WALSH

Abraham Lincoln and the London Punch

New York: Moffat, Yard and Company, 1909.

This book is a compilation of cartoons of Abraham Lincoln that appeared in Britain's premiere comic weekly, *Punch*. The cartoons are noteworthy because England had a pro-Southern bias owing to its need for southern cotton and its historical animosities with the U.S. As a result, the cartoons generally portrayed Lincoln in an unfavorable way.

JOHN TENNIEL

Lincoln's Two Difficulties

August 23, 1862, in Punch, or the London Charivari *(Vol. 43). London: Bradbury and Evans, 1862, p. 77.*

Tenniel, *Punch*'s chief cartoonist, depicts a slovenly and dispirited President Lincoln, dressed in clothes that would gradually come to be associated with Uncle Sam, the symbol of the United States. This cartoon appeared in August of 1862, before the Battle of Antietam, which ended Confederate General Lee's first invasion of the North and is considered a turning point in the Civil War.

A.M. BROADLEY

Napoleon in Caricature: 1795-1821

2 vols. London: John Lane; New York: John Lane Co., 1911.

This two-volume set featuring caricatures of Napoleon suggests the great quantity and diversity that were created. The first volume collects and analyzes English caricatures, while the second includes French, Russian, German, Italian, Spanish, Scandinavian, and Dutch caricatures.

JOHN ASHTON

English Caricature and Satire on Napoleon I

2 vols. New York: Scribner and Welford, 1884. First American edition.

This first edition is another two-volume set devoted to satires of Napoleon. In this case, they are of English origin exclusively.

JAMES GILLRAY

Armed Heroes

Published by Hannah Humphrey, Hand-colored etching, May 18, 1803

The Treaty of Amiens in 1802 produced a brief peace in the Napoleonic Wars, but fighting resumed in May of the next year. This famous Gillray satire ridicules the leaders of both sides. The United Kingdom's Prime Minister Henry Addington had worn his Woodley Cavalry uniform to the House of Commons to declare war on France, much to the amusement of some members of Parliament.[24] This is also an excellent example of Gillray's merciless caricatures of Napoleon, referred to here as "the little Bouncing B_."

This print was published by Hannah Humphrey, London's leading printseller, an extraordinary accomplishment for a woman at the time. By 1803, Gillray had been living above her shop and working exclusively for her for over a decade.

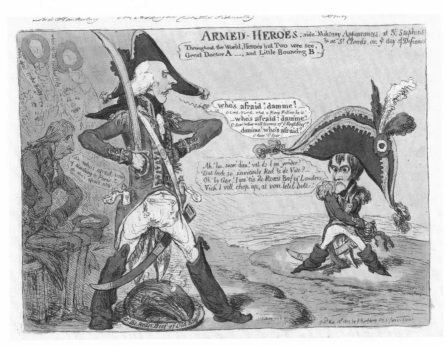

Armed Heroes

ARTIST UNKNOWN

[Step-ladder of Napoleon's Rise and Fall]

c. 1815, in Friedrich Schulze. Die Deutsche Napoleon-karikatur. *Wiemar: Gesellschaft Der Bibliophilen, 1916, plate 9.*

This book collects German cartoons of Napoleon. The cartoon exhibited is a variation of a similar one published in 1814 called the *Step-ladder of Napoleon's Rise and Fall*.[25] Both depict the various stages of Napoleon's life and rise to power on steps ascending from left to right and culminating with a depiction of Napoleon as Emperor at the top of the ladder. Next, the stages of his fall from power are shown on descending steps as he is forced out of Spain, Russia, and then Germany. In this version, Napoleon ends underneath the "ladder" in the flames of hell, while in the earlier version, he is shown merely exiled in Elba. Other variants of this design also exist, indicating its popularity.

PAUL CONRAD

Abraham Lincoln

Bronze, 1998

Paul Conrad's sculpture of Abraham Lincoln captures him in a classic pose that exaggerates his height and thinness, giving him a larger-than-life yet fragile quality.

Ghandi, Ulysses S. Grant, Abraham Lincoln and Theodore Roosevelt

Pot belly figurines, Hand-painted marble and resin

These contemporary figurines are part of a series of historical figures. The originals were sculpted at Martin Perry Studios in England. Each is approximately 2" tall, comes with its own trading card and has a secret compartment inside.

AMERICA'S GREATEST 19ᵀᴴ CENTURY CARTOONIST: NAST

THOMAS NAST

Mrs. Grundy cover

July 8, 1865, in Mrs. Grundy *(Vol. I, No. 1). New York, 1865.*

This beautiful image by Thomas Nast graced the cover of each issue of the satirical weekly, *Mrs. Grundy*. It depicts an old lady addressing a theatre full of famous personalities of the day. Mrs. Grundy was a fictional character who came to represent the arbiter of what is right and proper in respectable society. The origin of the name is the 1798 play *Speed the Plough* by Thomas Morton, in which one of the characters frequently worries what her neighbor Mrs. Grundy will say or think. The magazine was short-lived, lasting only twelve issues.

Nast's Illustrated Almanac for 1874.

New York: Harper and Brothers, 1873.

Starting in 1871, Nast published yearly illustrated almanacs for five years. In addition to the standard charts detailing sunrises, sunsets and the phases of the moon; Nast's almanacs featured illustrated stories, articles and poems by the likes of Mark Twain, Charles Dickens and fellow cartoonist Frank Bellew. This example from 1874 boasts eighty-six illustrations by Nast.

THOMAS NAST

Spoiling for a Fight

Harper's Weekly, *Wood engraving, December 28, 1878*

Here Nast depicts British Prime Minister Benjamin Disraeli (Lord Beaconsfield) prodding a miserable-looking John Bull into war with Afghanistan. Sher Ali, the Emir of Afghanistan, had refused to receive a British diplomatic mission in September of 1878. The British responded by sending troops to invade the country early in 1879 in what is called the Second Anglo-Afghan War.

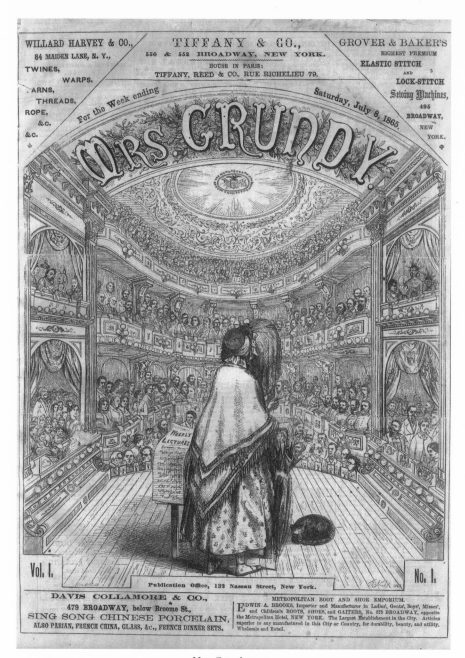

Mrs. Grundy cover

THOMAS NAST

Can the Law Reach Him?—The Dwarf and the Giant Thief

Harper's Weekly, *December 27, 1879*

The Dead Lock—And Now the Democratic Tiger Has Lost His Head

Harper's Weekly, *July 8, 1876*

Stranger Things Have Happened

Harper's Weekly, *January 6, 1872*

Wood engravings

These three *Harper's Weekly* cartoons by Thomas Nast feature his most recognizable and enduring images. The first is a wonderful caricature of Boss Tweed, depicted as a grotesquely-fat giant, beyond the reach of the law. The second shows the Tammany Tiger, a symbol made famous by Nast that came to represent the corrupt New York ring. The third cartoon features the Republican elephant and the Democratic donkey, symbols popularized by Nast and still used today.

INTERNATIONAL MAGAZINES

M. DICHON

Actualidad

March 15, 1874, in La Ortiga y el Carrote *(Vol. 1, No. 15). Montevideo, Uruguay, 1874.*

This volume of the political cartoon magazine *La Ortiga y el Carrote* [*The Stinging Nettle and the Stick*] illustrates the richness of the art of political satire in South America in the 1870s.

ARTIST UNKNOWN

Raising the Ghost of Sir Robert Peel, and His Peelers

September 15, 1866, in Dunedin/Otago Punch. *Dunedin, New Zealand, 1865-1866.*

The London comic magazine *Punch* had imitators throughout the English-speaking world. This example is from the South Island of New Zealand. The discovery of gold in the Otago Province in 1861 led to a sudden influx of population. As a result, Dunedin, the capital of Otago, became New Zealand's largest city in 1865, even though it had been founded only seventeen years earlier.

George Grey served as Governor of New Zealand from 1845-54 and 1860-68 during the Land Wars, a series of conflicts between the colonists and the native Maori lasting from 1845 until 1872. Grey is "raising the ghost" of former British Prime Minister "Sir Robert Peel and his Peelers" to solve the problem with the Maori. Peel established the first modern police force in 1829 when he served as Home Secretary. The constables in the new force were dubbed "Peelers."

D. C.

Arrêt de la cour prévôtale

January 27, 1831, in La Caricature *(No. 13). Paris: Aubert, 1830-31.*

Charles Philippon founded *La Caricature*, an early French satirical journal, after the July Revolution of 1830 led to a brief period of press freedom.

It contained four pages of text along with several satirical lithographs printed separately and inserted. Philippon was jailed numerous times for ridiculing King Louis Philippe in *La Caricature*, which he was finally forced to stop publishing in 1835. He immediately turned his full attention to a second humor weekly he had started, *Le Charivari*, which became the model for the British magazine *Punch, or the London Charivari*.

EDWARD THONY
Zwei Besiegte [Two Losers]
November 25, 1912

and

WILHELM SCHULZ
Die Seiger [The Winner]
December 2, 1912, in Simplicissimus. *Munich: Simplicissimus Verlag GmbH., 1912, p. 580-581.*

Founded in 1896, *Simplicissimus* was a German weekly magazine known for its liberal satire, modern graphic design and bold colors. In 1898, Kaiser Wilhelm II objected to the magazine's depiction of him, which resulted in the imprisonment of cartoonist Thomas Heine and writer Frank Wedekind and the five-year exile of editor Albert Langen. In spite of this, the magazine survived and prospered, continuing to lampoon all forms of authority including the monarchy, the military and the aristocracy. As of 1910, German officers were required to sign a statement pledging not to read *Simplicissimus*.[26]

The cartoon *Zwei Besiegte* features a fascinating caricature of Teddy Roosevelt, whose presidency ended three years earlier in 1909. The caption reads, "Listen, Roosevelt, nobody would believe us today that they once held a parade here to honor us."

ARTIST UNKNOWN
La Flaca cover
April 3, 1869, in La Flaca *(Vol. I, No. 2). Barcelona: D. Juan Prim, 1869.*

This is the first volume of the Spanish political cartoon magazine *La Flaca*, which shows the high quality of the satirical tradition which spread throughout Europe in the nineteenth century. La Flaca means "the skinny woman" and the masthead depicted an emaciated woman and lion.

Zwie Besiegte [Two Losers]

Procession to the Hustings

Engraving, 1790, in The Attic Miscellany *(Vol. I, No. 10). London: Bentley and Co., 1790., p. 361.*

The Attic Miscellany, a monthly magazine which was founded in 1789 and lasted until 1792, was the first periodical to publish political cartoons in each issue. This engraving, which folds out, depicts a motley parade of Whigs on the way to the hustings, the platform from which Parliamentary candidates gave campaign speeches. The cartoon accompanied satirical verse entitled "The Election."

Le Persecuzioni dei Governi Liberali [The Persecutions of the Liberal Governments]

July 14, 1860, in Il Lampione. *Florence: Carlo Collodi, 1860, unpaged.*

The satirical journal *Il Lampione* was first published in Italy in 1848, but it was suppressed by the Grand Duke of Tuscany after a run of only one year. Its founder Carlo Collodi revived it in 1860, on the eve of the unification of Italy. Collodi, whose real name was Carlo Lorenzini, is best remembered as the author of *Pinocchio*. This cartoon satirizes the Catholic Church, depicting "A Monsignor who leaves for the martyrdom" as a skinny, simple man, and "A Monsignor who returns from the martyrdom" as a fat, haughty man.

El Manjar de la semana

October 21, 1916, in Variedades *(Vol. 12, No. 451). Lima: Empresa editora "La Chronica"-"Variedades," 1916, p. 1372-3.*

The Peruvian satirical magazine *Variedades* commented on politics, society and world events from 1908 until 1932.[27] The cartoon on the cover features an interesting caricature of Woodrow Wilson as Uncle Sam. This volume was acquired during a trip to Peru, along with other magazines containing political cartoons dating back 100 years.

Cartoon No. 1 - Substance and Shadow

1843, in Punch, or the London Charivari *(Vol. 5). London: Bradbury and Evans, 1843, p. 23.*

Punch was the most successful and longest-running of all comic weekly magazines. Founded in 1841, it was published continually until 1992, then briefly revived again from 1996-2002. It looked to the French satirical magazine *Le Charivari* for inspiration, and then proceeded to inspire hundreds of others comic weeklies around the world.

The magazine gave the English language the modern usage of the word cartoon. Originally, the word referred to a preliminary sketch for a mural or tapestry. In 1843, the Palace of Westminster was being rebuilt after having been destroyed by fire. Preparatory sketches, or cartoons, of grand historical murals meant for the new Houses of Parliament were exhibited. *Punch* ran a series of its own satirical "cartoons" ridiculing the pretensions of the politicians. The first "cartoon" in the series, *Substance and Shadow*, criticizes the government for spending money on fine art when people were starving.

ANDRE GILL

Charles Dickens

June 14, 1868, in L'Éclipse *(Vol. I). Paris, 1868-1870.*

This famous caricature of Charles Dickens stepping over the English Channel from London to Paris appeared on the cover of the French comic magazine *L'Éclipse*. The publication succeeded an earlier magazine called *La Lune*, which had been banned by Napoleon III's government in December 1867. An official was said to have remarked to *La Lune*'s editor Francis Polo that *"La Lune* will have to undergo an eclipse." Eight months later, Polo founded *L'Éclipse* which was almost identical to *La Lune* including a similar masthead and cover caricatures by André Gill. *L'Éclipse* survived until 1876.

André Gill is a pseudonym for the artist Louis-Alexandre Gosset de Guînes, who chose the name Gill because of his admiration for James Gillray.

NOTES

1 E. P. Richardson, "Four American Political Prints," *American Art Journal* 6, no. 2 (Nov. 1974), 36-44.

2 Ibid.

3 Joseph Grego, *Rowlandson the Caricaturist* Vol. I (London: Chatto and Windus, 1880), 105.

4 Joseph Grego identifies the figure as Lord North (p. 105), but in Dorothy George (*Catalog of Political and Personal Satires*, p. 515), he is identified as either George III or Lord North. The catalog of the National Portrait Gallery identifies him as George III (www.npg.org.uk).

5 Grego, 106.

6 Brian T. Neff, "Fracas in Congress: The Battle of Honor Between Matthew Lyon and Roger Griswold," *Essays in History* 41 (University of Virginia Corcoran Department of History, 1999).

7 Frank Weitenkampf, *Political Caricature in the United States* (New York: New York Public Library, 1953), 122.

8 Bernard Reilly, *American Political Prints, 1766-1876: A Catalog of the Collections of the Library of Congress* (Boston: G.K. Hall, 1991), 441.

9 William J Cooper, Jr., *Jefferson Davis, American* (New York: Alfred A. Knopf, 2000), 534.

10 According to reviewer T. Harry Williams in the *Journal of Southern History* 31, no. 4 (Nov. 1965): 466, Butler's biographer, Marvin R. Cain, convincingly refutes this claim, although valuables including spoons were legally confiscated for use by the Union forces during Butler's administration of the city.

11 http://www.typewritermuseum.org/collection/timeline/index.html.

12 David E. E. Sloane, ed., *American Humor Magazines and Comic Periodicals* (Westport: Greenwood Press, 1987), 367-8.

13 Richard Samuel West, *Satire on Stone: The Political Cartoons of Joseph* Keppler (Urbana and Chicago: University of Illinois Press, 1988), 65.

14 Kenneth D. Ackerman, *Boss Tweed: The Rise and Fall of the Corrupt Pol Who Conceived the Soul of Modern New York* (New York: Carroll and Graf Publishers, 2005), 310-312.

15 Sloane, 112-113.

16 Sloane, 102-3.

17 Richard Samuel West, "Light," http://www.periodyssey.com/private/history3.htm.

18 Sloane, 52-54.

19 http://www.whitehouse.gov/history/presidents/bh23.html.

20 Mark Bryant and Simon Heneage, *Dictionary of British Cartoonists and Caricaturists 1730-1980* (Hants, England: Scolar Press, 1994), 115.

21 Translation by Cornell Fleischer, Kanuni Suleyman Professor of Ottoman and Modern Turkish Studies at the University of Chicago.

22 Wendy Wick Reaves, "Thomas Nast and the President," *The American Art Journal* 19, no. 1 (Winter 1987), 60-71.

23 Partha Mitter, "Cartoons of the Raj," *History Today* (September 1997), 16.

24 Charles John Fedorak, *Henry Addington, Prime Minister, 1801-1804: Peace, War, and Parliamentary Politics* (Akron, OH: The University of Akron Press, 2002), 139.

25 A.M. Broadley, *Napoleon in Caricature 1795-1821*, vol. 2 (London: John Lane, 1911), 130-131, 392.

26 Eve Lucas, "Simply Red," *Munich Found Online*, http://www.munichfound.de/new.cfm?News_ID=1680.

27 http://www.crl.edu/areastudies/LAMP/collections/lampprojects.htm

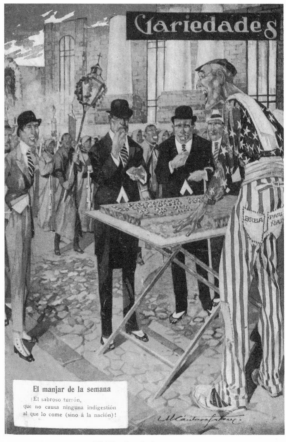

El Manjar de la semana